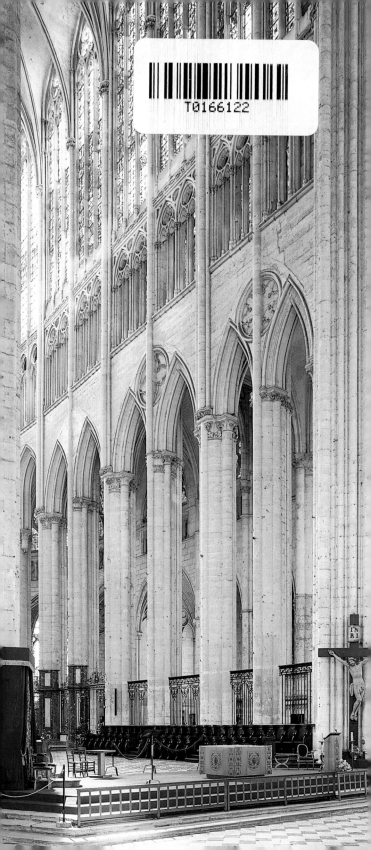

the transept and nave. Martin Chambiges, a master mason from Paris, was entrusted with the project. Work was started first on the south transept and the first stone was laid by Bishop Louis de Villiers de l'Isle-Adam in 1500.

Martin Chambiges died in 1532, but work continued following his plans after his death. In 1537 stained-glass windows were installed in the north transept, which was covered and roofed in 1538-1540. The roof of the south transept was finished in 1548 and a statue of Saint Peter placed at the top of the south facade. The vaulting in the south transept was finally completed in 1550.

Instead of continuing work with the construction of the nave, the chapter decided to build a huge tower topped with a lantern above the transept crossing. Plans for the tower were drawn up by the architect Jean Vast and were adopted in 1561. The tower was finished six years later; the pyramid-shaped framework which surmounted it was covered with lead and crowned with an iron cross.

The tower made Beauvais the tallest cathedral in Christendom; it even outstripped Saint Peter's in Rome. Unfortunately this architectural triumph was not to last. Fears about a possible accident started as early as 1572 when the iron cross surmounting the lantern was taken down as it was considered too heavy. A year later disaster struck and the tower collapsed on Ascension Day (30 April 1573). Luckily the congregation had just processed out of the cathedral and there were no casualties.

The damaged sections were immediately repaired. The vaults in the choir and transept destroyed by the accident were rebuilt and the transept crossing was covered with wood, but the construction of a massive tower was now out of the question and Jean Vast's spire was replaced by a simple bell-tower. There was only room for some of the cathedral's bells in this new tower and the rest were put in an adjacent tower, which no longer exists, close to the south door of the cathedral.

However, the plan to finish the cathedral had not been abandoned. Although it was put on hold during the last quarter of the 16th century, construction, under the direction of the master mason Martin Candelot, was started again in 1600. In 1604 the first bay of the nave was vaulted and a provisional palisade erected to close off the cathedral to the west. However this barrier eventually became permanent as Beauvais cathedral was never finished. Work carried out during the 17th and 18th centuries was mainly on the cathedral's interior decoration: the rood-screen was remade in 1680 and the high altar by the sculptor Adam was installed in the mid 18th century.

At the Revolution the cathedral was turned into a simple parish church and lost much of its furnishings, in particular its gold and silver reliquaries which were sent to the Mint in Paris to be melted down. In the first decades of the 19th century, the church (restored to its cathedral status in 1822) succeeded in regaining some of its dignity as it was endowed with some of the items lost from Beauvais' other religious establishments, including the abbot's throne from the abbey of Saint-Lucien and the choir stalls from Saint-Paul-lès-Beauvais.

2. *Detail of the tapestry of the Life of Saint Peter (15th century).*

3. *Imaginary model of the planned cathedral.*

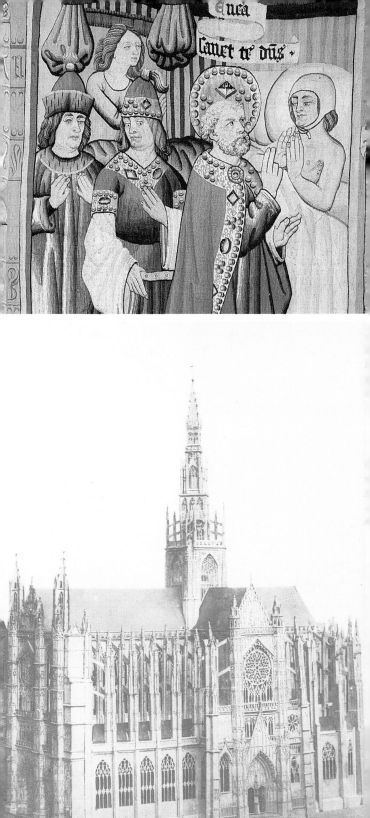

The cathedral was classified as a *historical monument* in 1840, when the list of buildings was first compiled. The architect Ramée, put in charge of drawing up a restoration programme in 1842, suggested extending the cathedral to the west by building one or two supplementary bays to support the church. This project, taken up by his successor Verdier, was finally abandoned in 1854. From then on the only work planned was restoration of the existing structure. Work was carried out on the structurally weak pyramids capping the piers of the flying buttresses from 1813 onwards. After 1861 the tiled roofs of the radiating chapels and the aisles were replaced by flat roofs in order to open up the obstructed triforium bays. The piers in the choir aisles were underpinned in 1897 and 1904.

The cathedral was not too badly harmed during the First World War. However, it was damaged by the bombardment of 1940 which destroyed the chapter sacristy, although compared to the rest of the city, the cathedral was relatively unharmed: it was only hit by five bombs and remained standing. The antique stained-glass figurative scenes had all been taken down and safely stored in the château de Carrouges in the Orne in 1939. Although the cathedral did not suffer too badly during the war, the surrounding canonical area was completely flattened; with the exception of its west end where the canonical cloister and the Bishop's Palace with its two round towers still stand, the cathedral of Saint-Pierre is today a building isolated from its historical context.

The long list of disasters affecting the cathedral is unfortunately still not finished. Recent disturbances have revealed new problems which have been temporarily solved by the supports currently disfiguring the cathedral. The external metal braces, whose recent removal lowered the building's wind resistance, are now about to be re-installed to buttress the cathedral. The building's impressive height has actually increased the risk of danger by making it more vulnerable to the wind. Perhaps the architect of Beauvais cathedral was too ambitious…

Tour of the exterior

The cathedral's plan reflects its history: the original parts were modified in the 14th century during the restoration of the section destroyed by the vault collapse of 1272, and then again in the 16th century, when the abandoned building programme was restarted after more than a century. In its current state, the cathedral has only a tiny section of nave and mainly consists of the choir and transepts. The prominent transepts consist of three sections, of three bays each. The choir is made up of six chancel bays and an apse surrounded by an ambulatory off which open seven radiating chapels. This plan is similar to that of Amiens cathedral, although the central chapel at Beauvais is the same size as the other chapels. However, the present plan is not exactly the same as the 13th-century plan: originally the choir had only three chancel bays (they were divided in two in the 14th century to strengthen the building) and there were towers, which were never built, planned for each transept.

From the cathedral parvis, you can see in one glance the different stages in the building of the cathedral. On

4. *The flying buttresses.*

5-6. *The upper parts of the cathedral.*

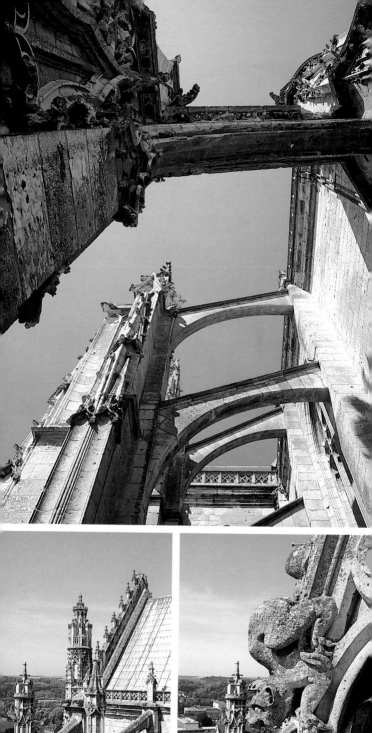
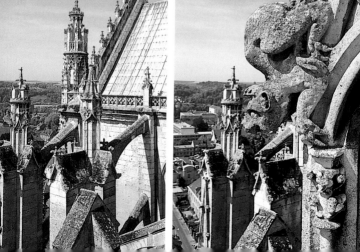

your far left there is a glimpse of the 10th- and 11th-century cathedral, now dwarfed by the vast Gothic building. To the right is the 13th-century choir and in the centre you can see the transept built by Martin Chambiges in the 16th century.

The **transept** is richly decorated in the Flamboyant Gothic style (1). The central section is framed by two turrets, which act both as buttresses and staircase towers, and give the facade a greater depth. This design can be seen in other Flamboyant Gothic buildings, such as the abbey church of Saint-Riquier and Martin Chambiges himself used it in the transept at Sens. The space between the two ornately decorated turrets is divided into several horizontal levels: the ground floor with the door surmounted by its gable, the clerestory, the rose window and finally the upper gable decorated with niches which finishes off the elevation. The richness and monumentality of this facade are almost certainly a result of the topography of the old city of Beauvais: the south door opened onto the most important road in the city and was thus a powerful status symbol for the chapter and the bishop.

Go up to the entrance door for a better view of the decorative details. Before the Revolution, the entrance was framed by statues of apostles, and scenes from the life of the cathedral's patron saint, Saint Peter, were depicted in the coving above. Unfortunately these sculptures disappeared in 1793, but the niches and the elaborate canopies which sheltered them still remain, as do the monsters and grotesques who people the vine branches surrounding the doorway. Most importantly, the cathedral doors have been saved; these date from the 16th century and their wonderful wooden panels, attributed to the sculptor Jean Le Pot, are

carved with, on the left *Saint Peter Curing a Lame Man at the Temple Door* and, on the right, *The Conversion of Saint Paul on the Road to Damascus*. Among the other figures depicted above the scenes is the salamander of Francis I, a benefactor of the cathedral. These sculptures are truly Renaissance in style, both in the modelling of the figures (look for example at Saint Paul's horse) and in their architectural frames decorated with scrolling branches and *putti*.

The **east side of the transept** (*to the right of the Flamboyant Gothic door described immediately above*) is an example of a totally different building style (2). This section dates from the Gothic cathedral's first construction period, started in 1225, and its elevation is unique as the rose window and external gallery above the lower bay are not repeated on any other wall of the cathedral.

The **apse** (3), which also dates from the 13th century, is particularly impressive thanks to its forest of flying buttresses whose lightness is in marked contrast to their height. They support the glazed shell which towers above the side chapels in the centre of the apse; the size of the choir windows is one of the distinguishing characteristics of Beauvais cathedral.

The outer supports of the flying buttresses are decorated with gables and slender small columns which make them seem less massive. The

7. *The upper section of the south transept facade.*

8. *Detail of The Conversion of Saint Paul, south door.*

9. *Detail of Two Evangelists Flanked by Sybils, north door.*

7
8 | 9

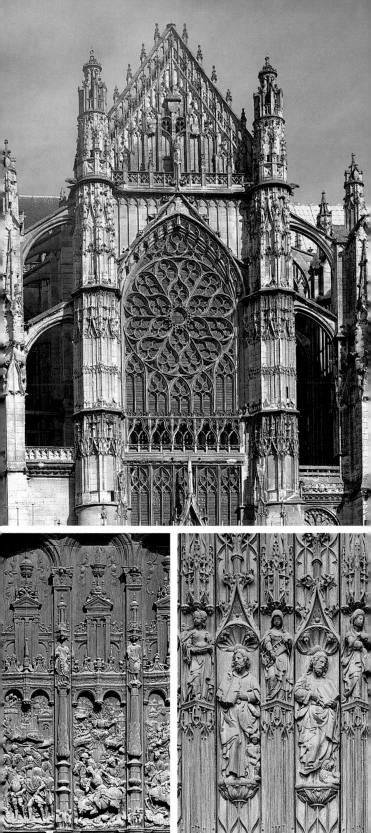

tops of the flying buttresses are worked with niches which still contain the mutilated remains of statues of saints.

Lower down the highly formalised elevation of the apse, is the ambulatory with its triangular bays, and then the chapels which form the base of the pyramid. Each chapel is built between two piers and is additionally supported by two smaller buttresses. They have the same cornice profile as the piers on either side, thus allowing the eye to pass along the line of chapels without interruption. The circular base of the chapels emphasises this fluidity. From here you can understand why the architects were unwilling, in spite of the large number of chaplains responsible for the central chapel's services, to differentiate it from the other chapels, as its extension would have broken the crown of chapels which surround Beauvais cathedral.

Walking round the apse, you now reach **the north transept** ④. This facade more or less mirrors the facade we have just seen on the south side, although it is slightly more simple. The main difference lies in the two buttresses flanking the central part of the facade; they seem much heavier than the complex and richly worked staircase turrets of the south facade. The north door is also decorated with 16th-century carved panels, again attributed to Jean Le Pot. They represent *The Evangelists* and *The Doctors of the Church Surrounded by Sibyls*, a theme which was popular during the late Middle Ages. Their style is more Gothic in inspiration than their southern counterparts; this can be seen particularly in the treatment of the niches which frame the figures. However, the detailing of the figures and the use of shells in the decoration is typical of the Renaissance.

To the east of the transept, you can see the sacristy surmounted by the treasury (*not included in the tour*). These two adjoining buildings to the side of the cathedral are part of the 13th-century construction.

Continuing round the cathedral, walk past the long blind wall enclosing the canonical **cloister** ⑤ built in the 15th century (*not included in the tour*). The 16th-century chapter-house is located in the east wing of the cloister.

The three remaining bays of the **Basse-Oeuvre** ⑥, the old cathedral built during the 10th and 11th centuries, are to the west of the cathedral of Saint-Pierre (*not included in the tour*). This church is much shorter than the Gothic cathedral, and its building material also distinguishes it from the later building; the walls are built out of small stones called "*pastoureaux*" which probably came from Roman monuments. The fragments of tiles found during excavations suggest that the original roof also followed a classical model. The 10th- and 11th-century interior would have been richly decorated, but only faint traces of this décor - remains of painted murals, *opus sextile* pavements and fragments of stained-glass - survive buried in the ground.

The church as it stands today is missing a considerable section of its elevation as in the 10th century the ground level was 1.8 metres lower than it is today. To visualise the original church, you have to imagine a building 18.5 metres high and

	10	
11		12
	13	

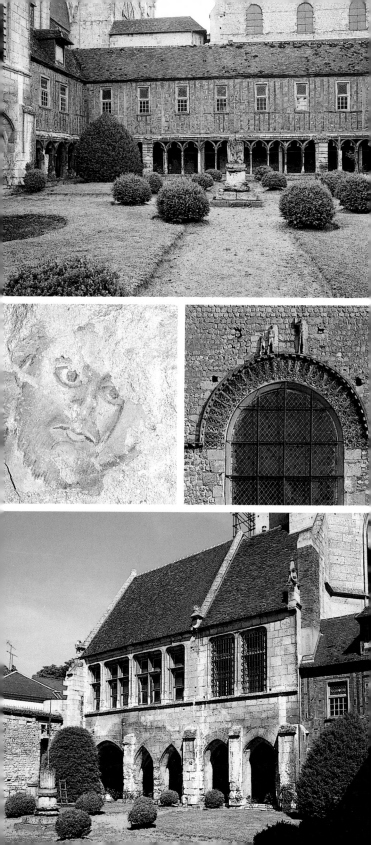

70 metres long; these dimensions are comparable to those of the large Carolingian churches. In spite of the construction of the Gothic cathedral in the 13th century, the Basse-Oeuvre continued to be used for worship and so was given a new, shorter apse. After building was restarted in 1500, this apse was in its turn destroyed, but excavations have revealed its outline under the cathedral flagstone floor.

The west facade of the Basse-Oeuvre is very simple. The entrance door is surmounted by a round arch and its archivolts are decorated with three figures in low relief. The lower part of the facade dates from the 10th century, while the upper part was rebuilt in the 11th century following a fire. Until the 19th century the facade was fronted by a projecting porch built in 1688. This seems to have been part of the original design as foundations of older porches still survive in front of the current facade, although there is no sign of them today.

A Neo-classical porch to the side of the Basse-Oeuvre leads to the "salle Saint-Pierre", which was used by the chapter as an archive and a library before the Revolution. The area was then converted into a law court and finally a museum.

The west front of the cathedral dominates this area. Its lack of decoration – the wall is almost completely blind – reminds visitors that the nave was never finished.

Opposite you can see the 14th-century circular towers erected to defend the Bishop's Palace after the revolt of the citizens of Beauvais against their bishop in 1305. The Bishop's Palace (today the Departmental Museum) is at the far side of the courtyard. Its Renaissance-style exterior hides an older building which dates from the

12th century. There used to be a passageway leading directly from the palace to the cathedral; there are still traces of this gallery visible in the cloister.

Tour of the interior

We now return to our starting point, the south transept door, and enter the cathedral of Saint-Pierre.

On walking through the doorway and entering the cathedral, the initial effect of propulsion is striking; the vault, 48 metres above the ground, is the tallest ever built during the Gothic period. However the choir is abruptly halted by the blank wall interrupting the nave to the west, making the interior of Beauvais cathedral, which is 70 metres long, seem both immense and truncated at the same time.

The east aisle of the **transept**, to the right of the entrance, is an example of the original style of the 13th-century construction period ⑦. The walls and piers are thick enough to support the towers which were never actually built. Construction here was interrupted just above the level of the large arcades and was not started again until 1500.

On the other side, the left of the transept ⑧ is a good example of the 16th-century style in which most of the transept is built. The piers have an undulating form and have no capitals as the vaulting arches spring directly from the body of the pier; similar piers were used at the neighbouring church of Saint-Etienne de Beauvais, where work on the reconstruction of the choir was started in

14. *The Bishop's Palace, seen from the top of the cathedral.*
15. *The choir.*

14
15

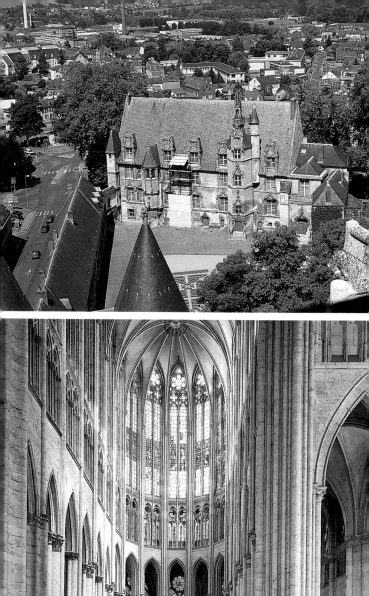

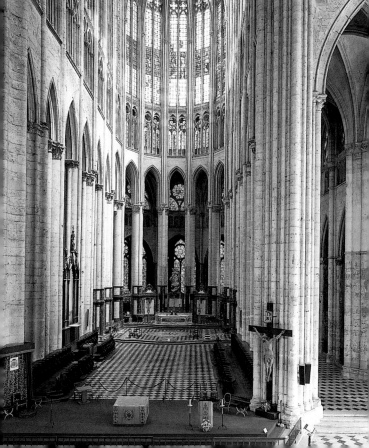

the early 16th century. The lack of both capitals and individualised small columns and the way the piers rise to the vault in a single burst give the transept interior a simplicity of decoration that contrasts with the luxuriance of the facade.

Looking up, you can see the dates 1550 and 1577 to the south of the transept, and 1578 to the north. A fourth date in Roman numerals, 1537, is visible above the north rose window. These inscriptions record the two stages of construction; 1537 and 1550 indicate the completion of the transept following Chambiges' plans. The two other dates correspond to the reconstruction work which was necessary after the collapse of the central tower in 1573. The wooden ceiling of the crossing, much lighter than a stone vault, was also installed at this later date (9).

The transept vaults are fairly simple in design and only the side chapels have a more complex system of vaulting of liernes and tiercerons (10). Throughout the ensemble, the 16th-century master masons sought to harmonise the transepts, both in the design of the vaulting and in their elevation, with the older choir. However the eastern walls of the transept lack the openwork gallery apparent in the choir; it has been replaced by a simple blind arcade which has the advantage of not weakening the wall (11). And in addition, the upper windows are decorated with elegant Flamboyant tracery.

In spite of these differences, the overall elevation of the transept repeats the division of the 13th-century choir into three levels. *There is a good view of the choir from the crossing* (12).

The three levels of the choir consist of, from bottom to the top, the tall

arcades, the triforium (the internal gallery) and the upper windows. The upper windows of the main section of the choir, *which is in front of you*, are particularly high and they give the cathedral its feeling of lightness and energy. The glazed triforium also contributes to this feeling as its windows increase the extent of the glass wall.

The lower level of the choir is composed of large arcades punctuated by circular piers, whose central core is surrounded by engaged columns. *As you can see when you enter the side aisle of the choir* (13), these piers are asymmetric; there are more columns on the aisle side than on the chancel side. The eye is thus allowed to glide over the piers of the choir, which are almost smooth, while in the aisle and ambulatory it enjoys the play of light and shade among the piers.

The division of the central body of the cathedral into three levels is repeated **in the ambulatory and the aisle of the choir**, *which we now walk down* (14), although the windows here are smaller and the triforium is not so well lit (in fact the 14th-century restoration work has left it completely dark, but originally it had small window bays).

It is quite rare for the aisle to repeat the elevation of the main body of the building in this way. This type of design creates an effect of spatial layering inside the cathedral. This impression is reinforced by the difference in level between the ambulatory and the side chapels leading off it; the gaze progresses from the lowest level, to the sides, up to the intermediate height of the ambulatory,

16. *Vaulting in the south transept chapel.*

17. *Detail of the Sybils in the north transept (1537).*

16
17

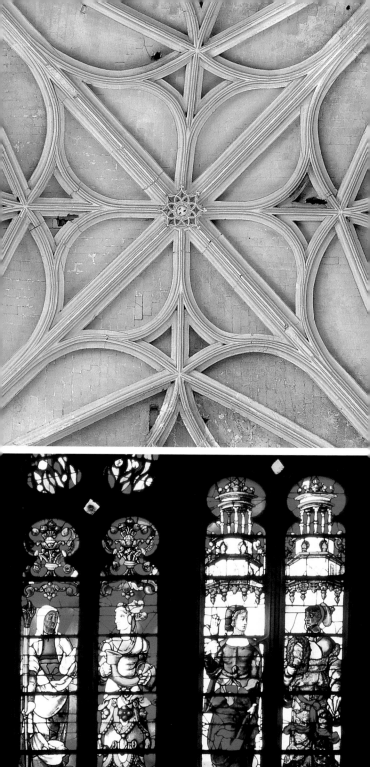

before reaching the height of the vault of the main body of the choir. The space, in spite of its vast dimensions, is thus unified. This pyramidal design was not repeated in the 16th-century transepts, where the two aisles are the same height.

We now enter the chancel (15) *. Looking closer at the elevation*, you can see that the uniformity of the 13th-century choir was threatened by the collapse of part of the vault in 1284. During the restoration work, the space originally conceived in the13th century was destroyed by the new piers added to support the vaults. The large arcades of the chancel bays were thus divided: the supports added in the 14th century pass through the original arches, traces of which are still visible. The 14th-century piers can be distinguished from the earlier ones by their smaller diameter and their sculpted decoration - the leaves on the capitals are more delicately worked. The **vault** was also reinforced. Each chancel bay has a sexpartite vault; in other words six ribs join to form a star-shaped configuration around the central boss. Originally there were only four ribs in each bay, following the style at Chartres or Amiens; the two extra ribs are 14th-century additions.

Nuances in the design of the upper part of the cathedral make it possible to see the differences between the original elevation, still visible at the far end of the choir, and the chancel bays rebuilt after the catastrophe of 1284. The small columns and the rose windows of the triforium are finer in the apse than in the west bays of the choir. In addition, originally the triforium was strongly linked visually to the upper windows: in the apse you can still see how the two lancets of the triforium are repeated in the upper windows so emphasising the upward thrust of the elevation. This design

was not repeated in the 14th century; in the chancel bays the triforium follows a binary rhythm while the upper windows are divided into three lancets with the result that the continuity between the two levels is interrupted.

The restoration work of the 14th century and the 16th-century additions however never threatened the impression of light and height which the original builders sought to create and the spaces between the supporting vaults are effectively walls of translucent, brightly coloured stained glass.

The cathedral of Saint-Pierre de Beauvais is home to a remarkable collection of stained glass dating from the 13th to the 20th century. The oldest glass, made in circa 1240, can be seen in the Lady Chapel. The glass in the upper windows of the east end of the choir, which was untouched by the 1284 accident, is also from the same period, although the upper windows of the chancel bays had to be re-glazed after the disaster in the late 13th or 14th century. The transept bays are decorated with very beautiful 16th-century stained glass from the Le Prince workshop (which also produced glass for the church of Saint-Etienne de Beauvais), while the side chapels contain examples of stained glass, sometimes fragmentary, from various different periods including the present day.

Interior decoration and artefacts

From the entrance of the cathedral to the end of the transept and back.

The history of the stained-glass windows by Jean and Nicolas Le Prince

18. Vaulting in the choir.

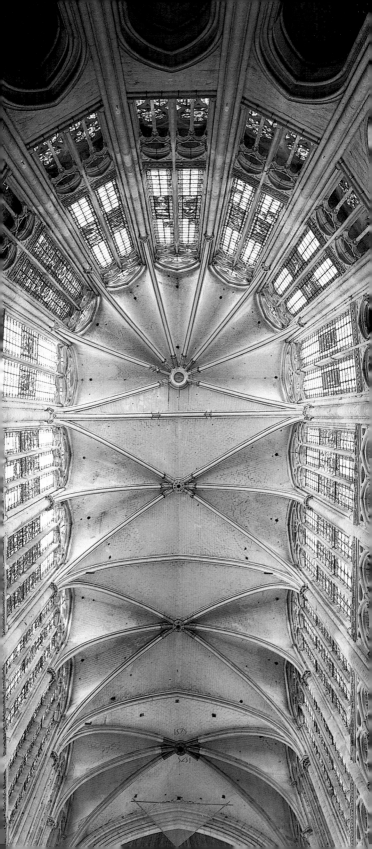

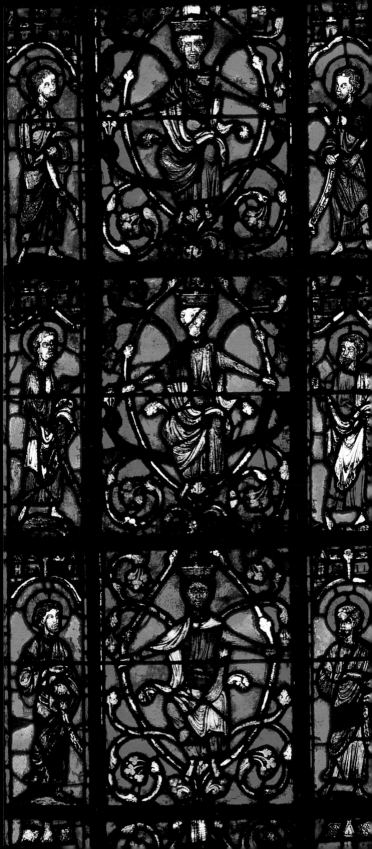

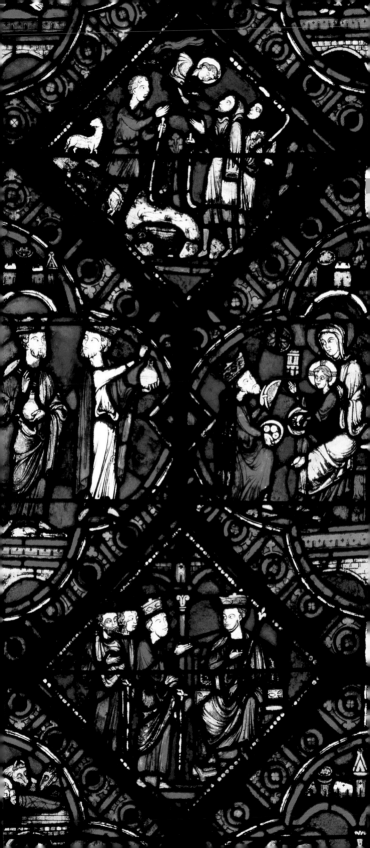

(1) installed in 1537-1538 opposite the entranceway in **the north transept**, reflects the turbulent history of the cathedral itself. Although the sibyls in the middle row have remained intact, the painter-glazier Max Ingrand remade the Le Prince rose window representing the sun, and the figures of the lower gallery, *The Wise and Foolish Virgins*, in 1958 following the destruction caused by the Second World War. The painting of *Christ Healing the Sick* beneath the windows is considered by some to be a genuine work by Jean Jouvenet, but more believe it to be a large-scale copy of the work the artist painted for the Carthusian church in Paris in 1689.

To the south west of the transept, the black and white doors worked with emotive skulls lead to the **Chapel of the Dead**, formerly the Chapel of Saint Peter and Saint Paul, and before that the Chapel of Saint Lucien (2). Its altar, erected in circa 1830, is composed of black marble ionic columns worked with vertical and spiral fluting which originally came from the old 17th-century rood-screen. The painting of *The Descent from the Cross* by Charles de la Fosse (1636-1716) also came from the rood-screen; it was painted before 1685, the date when it is mentioned in a description of the cathedral. Its pendant, *The Resurrection*, is in the ambulatory.

Two bells have been placed by the west wall of the cathedral, which marks the start of the unfinished nave; the first is *Guillaume* (3), and was commissioned in 1349 by the bishop of Beauvais, Guillaume Bertrand, and the second is *Pierre*, made in 1693 in the Nainville workshop, which was owned by a family of Beauvais founders (4).

To the west of the north transept, the **Chapel of the Sacred Heart**, also known as the Chapel of Saint

Barbara, is furnished with a complete ensemble originally in the church of Saint-Laurent and bought in 1803. It consists of an altar, an altar-piece, a tabernacle and a credence in painted and gilded wood dating from the 18th century and worked with fluted ionic columns and flaming urns (5). However the chapel is particularly remarkable for the stained-glass window in its east wall by Engrand le Prince which dates from 1522 (6). The glass depicts the donors, Louis de Roncherolles and Françoise d'Halluin, accompanied by their patron saints, Saint Louis and Saint Francis of Assisi, surrounding a *Pietà*. In the upper section you can see a Crucifixion scene, Saint Hubert with his stag and Saint Christopher, while the tympanum depicts *The Coronation of the Virgin*.

On the west wall, near to the entrance to the chapter-house, the painting of *The Denial of St Peter* depicts the moment when the cock crowing at dawn reminds the apostle of Christ's prophesy (7).

The stained glass by Nicolas Le Prince (8) in **the south transept** is dated 1551. The dates and glazier's initials can be seen in the phylactery of the prophet Amos (the eighth figure from the left in the middle row). Recently restored, the glass shows God the Father in the rose window, flanked by scenes from Genesis and the history of the Jewish people. In the middle row there

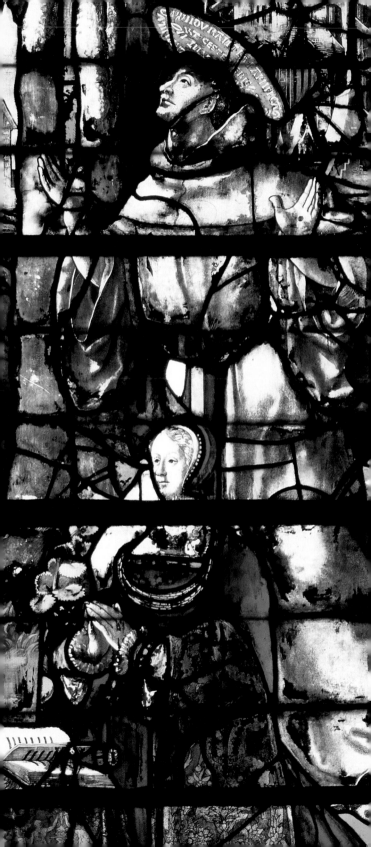

is a gallery of ten prophets displayed in architectural frames and lower down you can see the Four Evangelists, the Four Doctors of the Church and Saint Peter and Saint Paul.

Return to the centre of the cathedral and stop in front of the choir.

The choir was formerly sealed off by a rood-screen, a tall barrier dividing the congregation from the officiating priests, on top of which was normally placed a cross. The most recent rood-screen, which was destroyed in 1793, was erected in circa 1680 during the bishopric of Mgt Choart de Buzanval, and was designed by Léonor Foy de Saint-Hilaire, a cathedral canon. It was decorated with four statues of prophets, black marble columns and incorporated the two paintings by Charles de La Fosse.

It replaced an earlier rood-screen built in 1571 which was surmounted by a figure of Christ attributed to Nicolas Le Prince; this figure has now been identified as the statue standing by the entrance to the choir ⑨. The bishop's throne, on the other side of the choir, is decorated with a canvas hanging embroidered in *petit point* with large, typically 18th-century poppies ⑩. The rest of this set of furnishings, including the canopy valence and cushions, which are not used here are stored in the cathedral treasury (*currently closed to the public*).

Opposite the choir, you can see the pulpit ⑪ , dating from the second half of the 17th century, which became cathedral property after the Revolution in 1805; it originally came from the abbey of Saint-Lucien. The main section, supported by two kneeling slaves, one bearded and the other clean-shaven, is decorated with three panels depicting the figures of Saint Julien, Saint Maxien and Saint

Lucien dressed as a priest, deacon and bishop; all three were church leaders who were martyred at the same time in Beauvais in circa 290.

The cathedral organ ⑫ is now at the west end of the building, but when it was first made in 1530 it was housed in the Chapel of the Baptismal Fonts, also known as the Chapel of Saint Cecilia. It was made by two organ-makers from Lyons, Alexandre and François des Oliviers. The case was decorated with seven figures in low relief; they included Saint Cecilia with her organ, David holding his lyre and several of the Virtues. Painted by Scipion Hardouin and Adam Cacheleu, they were incorporated into the 19th-century organ and then moved to the treasury. They have been dated to the period 1530-1532 and their author would have been one of Jean Le Pot's immediate precursors. The 16th-century organ, too damaged to be repaired, was remade in 1827 by Cosyn, an organ-maker from the Royal School of Music in Paris, under the direction of P.-L. Hamel, and left in the Chapel of Saint Cecilia. It was not until 1979 that the instrument was restored by the organ-maker Danion-Gonzalez and put in its present position.

Before entering the ambulatory, stop and look at the **Chapel of the Baptismal Fonts**, the former Chapel of Saint Cecilia. On the east wall, the remains of a 14th-century fresco ⑬, are thought to depict the entrance into Beauvais of Cardinal

22. *Saint Thomas Aquinas, detail of the pulpit in the Chapel of Saint Angadrême.*

23. *Figures supporting the main pulpit in the transept crossing.*

24. *Engraving showing the 17th-century rood-screen.*

22 | 23
24

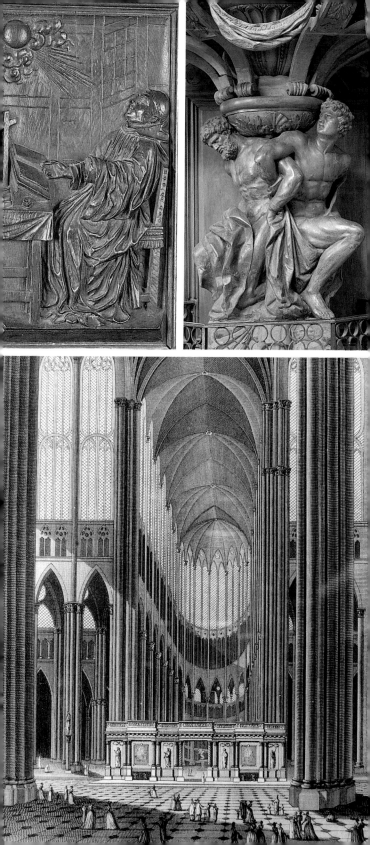

Jean Cholet, called de Nointel, as papal legate; he was the chapel's founder and died in 1291. Restored in 1989, the mural bears traces of various periods. The Crucifixion in the dog-toothed quatrefoil confirms the 14th-century date, but the upper figures flanking it, of which only one is visible, and their accompanying architectural framework seem to date from the end of the 14th century. Subsequent repaintings, some much later, have destroyed all the upper part of the scene. A stained-glass window was also part of this foundation, but has now disappeared. The present altar was not installed in the chapel until 1791 and originally came from the church of Saint-Sauveur. The red marble fonts date from the same period, while the stained glass is modern. It depicts *The Fountain of Life* designed by Claude Courageux, a painter-glazier from the Oise, and a *grisaille* by Anne Le Chevalier.

Anne Le Chevalier was also responsible for the stained glass in the **Chapel of Saint Angadrême**, the former Chapel of Saint Nicolas or Chapel of the Angels. The glass depicts scenes from the life of the saint and scenes from the life of Saint Nicolas, the former patron saint of the chapel. Saint Angadrême is highly venerated in Beauvais; she was abbess of the monastery of Orouer near Beauvais, where she died in 695, and is believed to have saved the city from fire. The good-quality statue in polychrome wood high up on a pier ⑭ dates from the 16th century and is attributed to a follower of Jean Le Pot. It depicts the saint dressed as an abbess tightly holding a cross, and although it is difficult to see, her face is ravaged by the disease that God inflicted in order to save her from marriage. In the same chapel you can see a chair that

was incorrectly believed to be that of the Présidial (the Ancien Régime court). Its shaped seat, the design of its marquetry and the cherubs decorating the arms, all suggest an early 18th century date.

The pulpit resting on a single modern stand dates from the end of the17th century and one of its panels depicts *Saint Thomas Aquinas Receiving Divine Inspiration while Writing the Summa Theologica*. The wrought-iron gates were made in circa 1780 by Jean-Baptiste Toussaint (or Poussain) and were gilded and painted by Doudeville in 1781. The gates to the following chapels also date from the 18th century.

The fine gilded wooden altar-piece in the **Chapel of Saint Leonard**, also called the **Chapel of Saint Vincent-de-Paul**, came from the Marissel church and was not installed in the cathedral until 1966 ⑮. Typical of local production and inspired by the northern models seen in many of the surrounding churches, it was painted by Nicolas Nitart and the carving is attributed to the sculptor Nicolas Le Prince. According to a contract of 1571, the work was originally commissioned with two accompanying side panels, today lost, depicting the Passion and scenes from the life of the Virgin. The Crucifixion in the centre is surrounded, from left to right, by scenes from the Passion: *The Arrest of Christ, The Presentation of Christ to the People, The Deposition, The Entombment* and *The Resurrection*. The predella shows

The Last Supper with the apostles depicted holding their attributes, and at the bottom of the central frame there is a scene showing *The Dormition of the Virgin.*

The contemporary stained-glass windows by Jeanette Weiss-Gruber incorporate the figures of two donor canons which date from the 15th century.

On the wall of the **Chapel of Saint Denis** there is a copy of Philippe de Champaigne's painting *The Dead Christ* by a local 19th-century artist, Henri Lejeune ⑯ .

In the doorway of the **Chapel of Saint Vincent**, or the **Chapel of Notre-Dame de Lourdes**, several memorial stones have been re-used as steps. The work on some is still visible: on the right you can see two angels carrying censers between three pinnacles, and on another fragment in the centre of the second step you can see a scene depicting a teacher. The stained glass in the central window dating from 1340-1350 comes from the chapel which used to be dedicated to Saint John the Evangelist and is now dedicated to Saint Anne ⑰ . In the left lancet you can see *Saint John on the Island of Patmos Writing to the Seven Churches of Asia*, and on the right he is attending the Crucifixion; Longinus, the centurion, is among the spectators. The donors, shown in the lower part of the window, were very likely members of the Brotherhood of Saint John the Evangelist. In the tympanum you can see a scene depicting *The Coronation of the Virgin* flanked by angels carrying musical instruments and a tetramorph. The side windows, dating from 1290, were given by Raoul de Senlis who has had himself depicted as donor in the lower level and whose name appears several times. The left bay is dedicated to the martyr Saint Vincent and the right bay shows *The Calling of Saint Peter and Saint Andrew* and *The Crucifixion of Saint Peter.*

To one side of the altar is four-footed brazier used by the incense-bearing priests. It is made of wrought iron and dates from the 16th century, although its four-faced covering is more recent.

Since the end of the 19th century, several pictures formerly in various different chapels, have been displayed in the **ambulatory** ⑱ along the wall of the choir. *The Agony of Christ on the Mount of Olives,* dating from the 18th century, shows Christ kneeling on his cross shrinking from the idea of death. He is supported by an angel and the instruments of the Passion – Judas' purse, the nails, the whip and the crown of thorns – lie scattered around him. The Latin inscription recalls the bitterness of the chalice, which is depicted in the foreground resting on one arm of the cross: "Why fear the bitter chalice? Drink, Jesus, that which the desire and love of the Father offers you." There are two unidentified coats of arms in the bottom right-hand corner.

The next picture, signed and dated "R de Ronssoy faciebat, 1737" depicts *Christ on the Cross between Saint Charlemagne and Saint Louis,* with Mary Magdalen kneeling at the foot of the cross. An extract from psalm 96, "Justitia et judicium correctio sedes ejus" painted

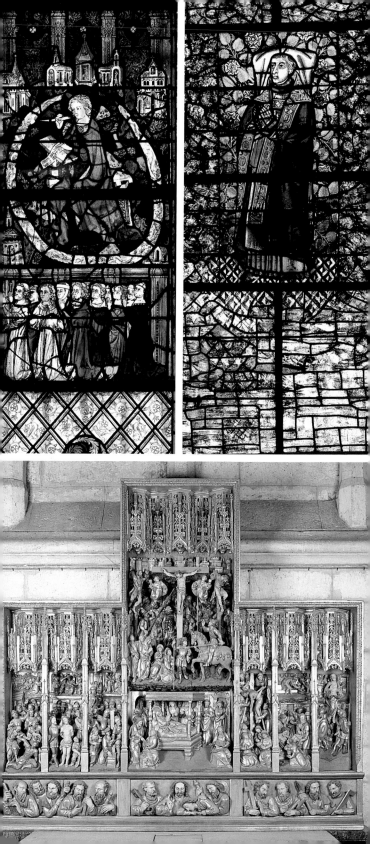

on the frame suggests that it formerly hung in a law court, perhaps that of the chapter or the Bishop's court (ecclesiastical court).

The Resurrection by Charles de La Fosse, like its pendant *The Deposition* displayed in the Chapel of the Dead, comes from Choart de Buzanval's old rood-screen.

The most interesting items in the **Chapel of Saint Joseph** (19) are the contemporary stained-glass medallions by Louis Barillet depicting the childhood of Christ. Further along the ambulatory, in the Chapel of Saint Lucien, there are windows by the same artist depicting the saint and scenes from his life.

Dedicated to the Virgin in the 13th century, **the central radiating chapel** or **the Lady Chapel** (20) has the oldest stained-glass windows in the cathedral, dating from circa 1240. Scenes from the life of Christ are depicted in the central bay (although *The Circumcision* is a modern replacement), while *The Ascension* and *The Tree of Jesse* can be seen in the left-hand lancet and *The Crucifixion* in the rose window. The left-hand window shows scenes from the life of a Saint-Bishop, usually held to be Saint Martin, but sometimes identified as Saint Constantin, a 7th-century bishop of Beauvais and a contemporary of Saint Angadrême. The right-hand window depicts *The Miracle of Theophilus*, which tells the tale of the deacon, who, having sold his soul to the devil, implored the Virgin to save him and she mercifully seized the contract from the devil. The modern glass in the rose window shows the Virgin and the devil fighting for the soul of the unfortunate Theophilus.

Claudius Lavergne (1814-1887), a pupil of Ingres and follower of Lacordaire, was entrusted with the chapel between 1856 and 1858; he helped restore the religious painting, but above all he made a name for himself as a designer of stained-glass windows. Prior of the Third Order of Saint Dominic, that of Fra Angelico, Claudius Lavergne gave the cathedral a Neo-Gothic altar decorated with four lobed medallions depicting scenes from the life of the Virgin: *The Annunciation*, *The Nativity*, *The Virgin Mourning the Dead Christ* and *The Coronation of the Virgin*. The altar itself is decorated on a grand scale with a technique popular during the Middle Ages; metal leaf, in this case copper, is applied to a wooden core and encrusted with pieces of glass or semi-precious stones.

The **Chapel of Saint Anne** (21) has contemporary stained-glass windows depicting *The Life of Saint Anne* by Jacques le Chevallier. It was decorated with painted murals in the early 15th century, but only fragments of these remain today; although some figures, architectural details and traces of inscriptions are visible, it is impossible to identify the iconography of the whole scene.

Two canvases by Mauperin hang on the walls of the **Chapel of Saint Lucien** (22). *Mary Magdalen Divesting Herself of Her Worldly Trappings* is a copy of a picture by Le Brun and is dated 1780. It shows the saint turning away in horror from the jewels and symbols of luxury in front of her. *The*

31.	*The Agony of Christ, 17th century.*	
32-35.	*Four medallions from the altar of the Virgin painted by Claudius Lavergne in 1856.*	31 · 32 / 33
36.	*Resurrection of Christ, 17th century.*	34 / 35 · 36

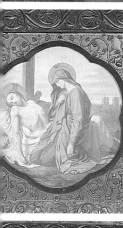

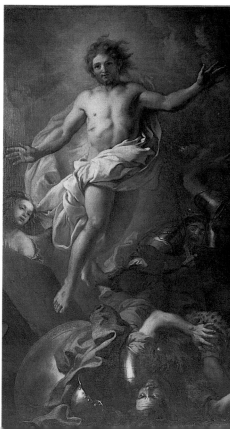

Pilgrims on the Road to Emmaus was painted in 1782 and, according to an inscription at the side of the picture, restored in 1835 by the artist Pavie. Mauperin was a fairly well-known artist; he was active until 1800 and was member of the Académie de Saint-Luc, where he exhibited in 1784, and winner of the third prize of the Académie royale in 1766. The chapel's wrought-iron gates were made by the smith Marc Brismontier and date from 1785.

The stained glass in the **Chapel of Saint Joan of Arc** (23) is modern. The glazier Michael Durand incorporated two 14th-century fragments depicting *The Coronation of the Virgin* and *The Crucifixion* into his designs representing *The Instruments of the Passion* (to the left) and *The Litanies of the Virgin*. The monument to Joan of Arc against the north wall, commissioned by Mgr Le Senne, bishop of Beauvais, was made by the sculptors Charles Desvergnes, Marc Jacquin and Gabriel Chauvin in 1930. It shows the bishop kneeling in front of the Saint praying for her to pardon Mgr Cauchon, bishop of Beauvais, for the role he played in the trial of the Maid of Orléans in 1431. The fine altar-piece of carved oak and black marble dating from the second half of the 18th century is today missing the canvas of *The Crucifixion* which completed it.

Several important items are housed in the **Chapel of Saint Theresa of Lisieux** (24), off which the doorway to the sacristy opens. The oldest of the chapel's items is the 14th-century striking clock, known as the clock of Etienne "Musique", a cathedral canon who died in circa 1323. It is probably one of the oldest clocks of this type in working condition in the world. It was restored in 1912 by the clock-maker Paul Miclet who gave it a new drum. It was then damaged in the 1940 bombardment and was repaired again in 1973-1974 after thirty years of silence. A polygonal stone shaft, almost five metres high, decorated with trefoiled arches and leafy brackets, hides the weights necessary for it to function; the shaft is pierced by a door and small windows. The wooden case, perhaps reconstructed and certainly repainted at the end of the 15th century, is decorated with four angels supporting the dial and has two coats of arms, one the arms of the chapter, at the top and the bottom. The dial, dating from the Louis XVI period, shows the lunar cycle. Above, the oldest clock bell known in France hangs in a wooden bell-tower. It is worked with an inscription commemorating the canon's commission: "Musicus canonicus Belvacensis me fecit fieri".

At the foot of the staircase leading to the clock mechanism, which allows access to the clock so it can be wound up, is the funerary monument of Cardinal Toussaint de Forbin-Janson, bishop of Beauvais from 1676 until his death in 1713. The bishop had wanted a bust by the sculptor Nicolas Coustou (1658-1733) for his tomb, but his nephew changed this request into a much larger-scale commission. The contract was signed in 1715 and the work was to have been delivered within two years. After preliminary work in 1715, the project was modified to accommodate the wishes of the canons who wanted to place the monument in the choir. However it was not installed until 1738, after the death of Nicolas Coustou and it was finished and erected by his brother William.

37. *Medieval clock.*

38. *Central section of The Pilgrims at Emmaus by Mauperin.*

$\dfrac{37}{38}$

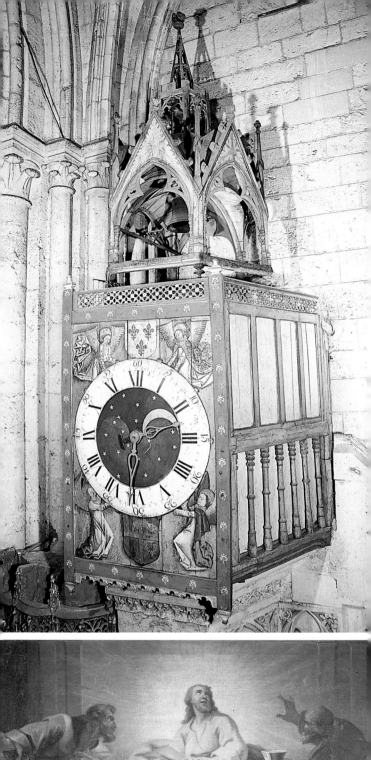

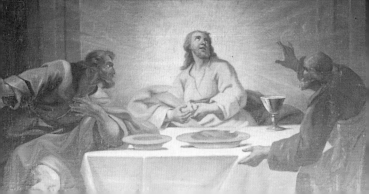

The cardinal is depicted kneeling on a cushion trimmed with tassels, in a slightly off-balance pose which recalls the figure of Louis XIV in Antoine Coysevox's work *Le Voeu de Louis XIII*. He is holding his cardinal's hat against his chest in one hand and he stretches out the other hand, which has been recently vandalised. The expressive head would have been looking towards the altar; the detailing of the lace is beautifully worked. When the monument was installed in the choir it would have been visible from all of the cathedral as a result of the partial destruction of the stone enclosure of the choir, an act which angered Bishop Mgr Potier de Gesvres. In 1793 the monument was thrown out of the cathedral on the demand of the Société populaire de Beauvais, and as the inscription indicates, it was only installed in its present position in 1804. Several types of marble have been used in the work; red Languedoc marble for the plinth, white marble for the pedestal and black marble for the plaques.

On the other side of the clock shaft, surmounted by a richly decorated Flamboyant Gothic-style canopy, there is an *Ecce Homo*. Worked in polychrome plaster, it dates from 1880 and was made by the Froc company in Paris. It replaced the *Suffering Christ* attributed to Jean Le Pot which stood there until the end of the 17th century. There is a pretty, carved-wood *Pietà* next door to it. The figures are placed under a finely worked canopy which is surmounted by the instruments of the Passion - nails, hammer, crown of thorns.

The astronomical clock in the **Chapel of the Holy Sepulchre,** or Chapel of the Cantor (25), was made between 1865 and 1868 by Auguste-Lucien Vérité, who was born in Beauvais in 1806 and died in 1887 and was responsible for the Besançon clock. Exhibited in Paris during the 1869 exhibition, the clock was installed in 1876 in the cathedral. It is worked in a Roman-Byzantine style and is made up of 90,000 pieces and 52 dials, which present 50 figures, and shows the hours as well as the movement of the planets and the lunar cycles.

The stained-glass windows in the upper windows of **the choir** (26) are definitely some of the oldest in the cathedral, but because of their height, they are not very easy to see. The central bay depicts Christ on the cross with the Virgin and is flanked by the apostles; it still retains its original iconography. The windows in the chancel bays, remade in the late 13th or early 14th century, are less homogenous and include scenes such as *The Communion of Saint Louis* and *The Stoning of Saint Stephen*. Some of the figures of local saints such as Saint Evrost, Saint Germer and Saint Just date from 1576, after the collapse of the tower.

The stalls, which we can divide into three groups, were bought by the church after the Revolution in 1801 and come from the abbey of Saint-Paul, the current *préfecture*. The first group dates from the mid 16th century, the second from the late 16th century and the third from the 17th century. They replace the ones made by Gilles Petit, a Beauvais carpenter, which were partially destroyed in 1573 and had disappeared by the end of the 18th century. With their pretty misericords, charming pew-end reliefs depicting Saint Peter,

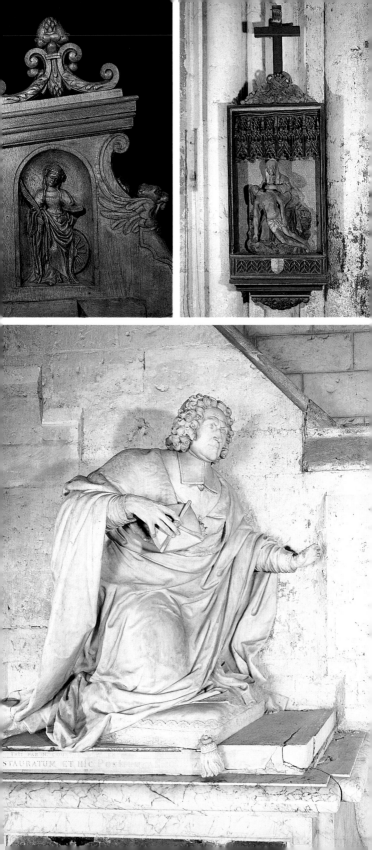

Saint Paul, Saint Catherine and Saint Barbara, and armrests decorated with animal heads and human figures, the stalls are well worth a careful look.

During the 18th century a major programme of redecoration was carried out in the sanctuary. The area is surrounded by tall wrought-iron grills which replaced the stone enclosure by Jean Le Pot and which fall into two groups. The first was specially made for the cathedral and by the Parisian smiths Antoine Pichet and Benoît and Gabriel Parent following designs drawn up by the architect Beausire le Jeune. Consisting of two large gateways and the iron grills in the two sanctuary bays, they were installed on 26 August 1739 and were probably finished by 1757-1758, the period of the major redecoration project in the choir. The second group was installed during the Revolution and consists of items from other churches in Beauvais, the church of Saint-Sauveur and the church of Notre-Dame du Châtel.

The bishops of Beauvais were traditionally buried in the choir, but during the redecoration work of 1755 the medieval tombs in enamelled copper were removed and were replaced with the present paved floor. It is worked with marble medallions inscribed with the names of bishops, a central polychrome rose and a cartouche of grey and white marble.

Following a decision taken by the chapter in 1748, Nicolas-Sébastien Adam (1705-1778), a member of a family of Lorraine sculptors who were great disseminators of the Rococo style, was entrusted with the redecoration of the choir. The project included a new altar, two credences for either side of the altar and a statue of the Virgin, as well as all the architectural décor. The new altar was inaugurated in 1758; made of polychrome marble it was richly decorated with gilded bronzes which included scrolling patterns at the back, a cartouche worked with the lamb and the seven seals on the front and chubby cherubs at the shaped corners. Above the altar you can see Adam's statue of the seated Virgin holding the holy Child, who is standing on a globe and stabbing a serpent with a lance in the shape of a cross; the statue is made of plaster as the marble was never delivered. Its iconography commemorates the famous altar dedicated to Our Lady of Peace by Louis XI and blessed in 1473, placed against one of the piers of the sanctuary. Two gilded wooden and marble credences or side tables, whose spheres harmonise with the shape of the columns behind, surmounted with crystal and gilded-bronze chandeliers, complete the sumptuous decoration of the choir.

42. *Sculpture of Virgin and Child by Adam.*

43. *High altar.*

$\frac{42}{43}$